Barry Frydlender

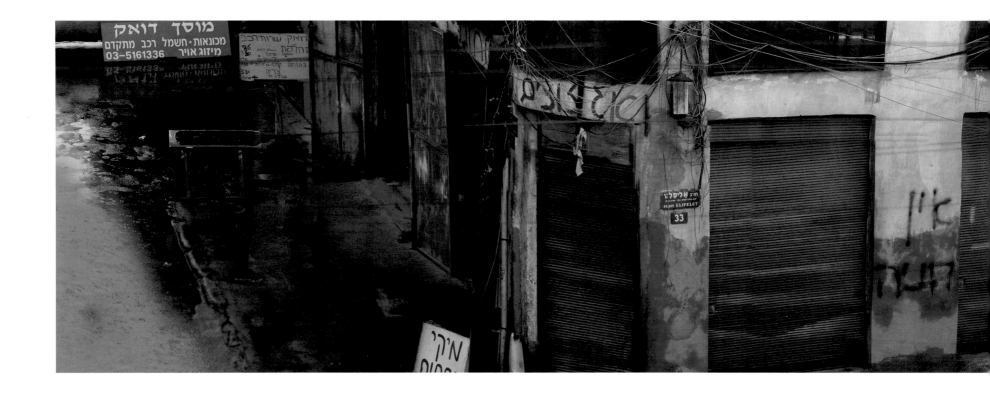

Barry Frydlender: Place and Time

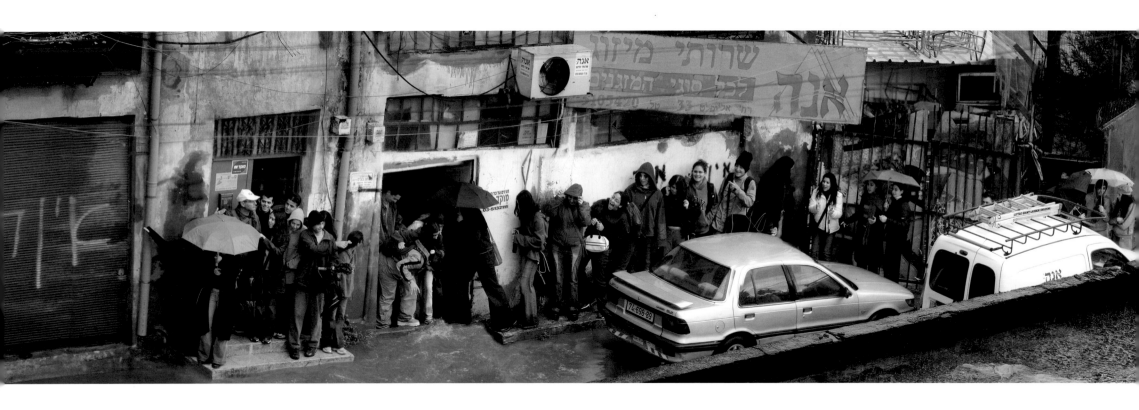

The Museum of Modern Art, New York

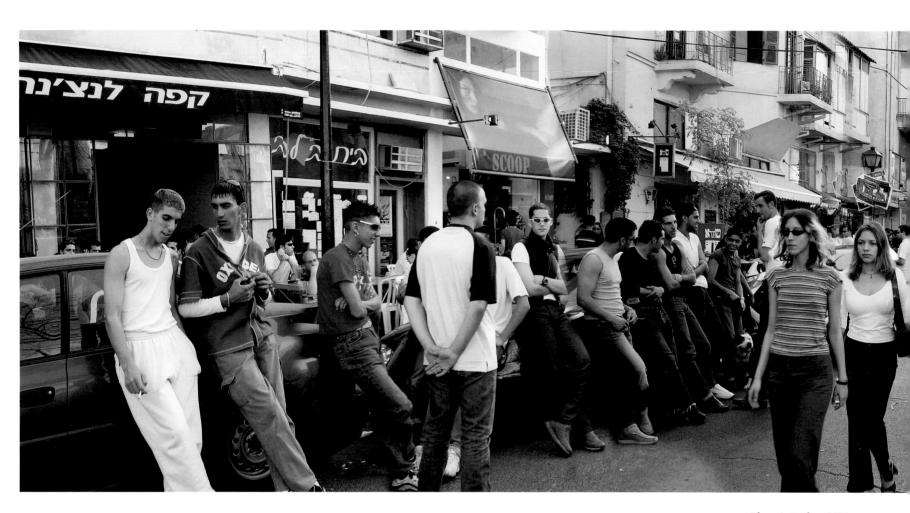

Plate 1 *Friday*. 2002

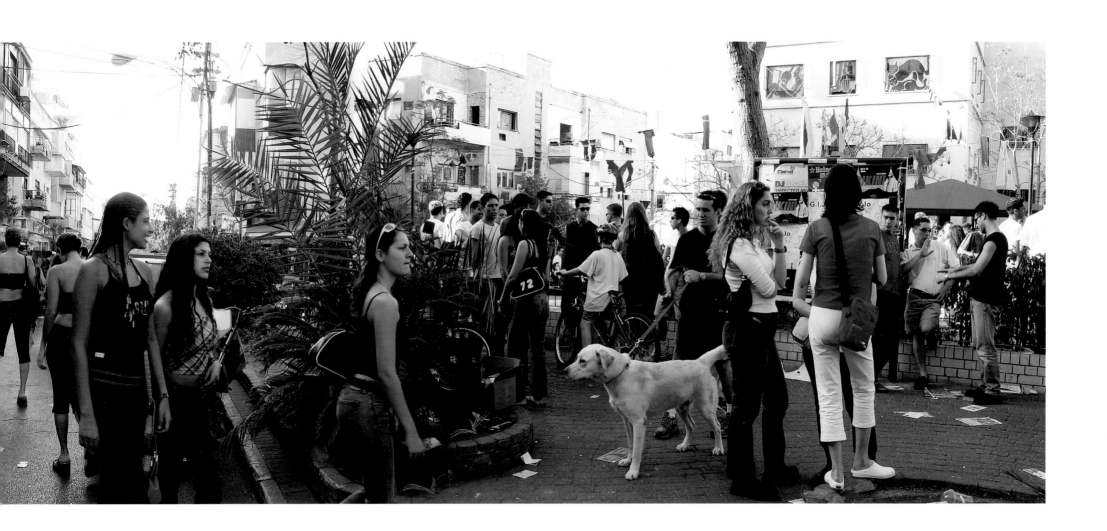

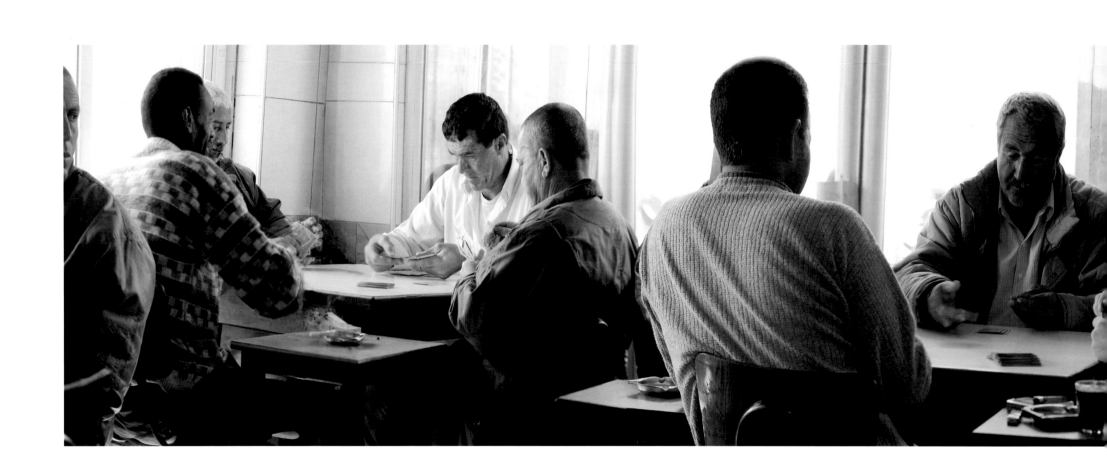

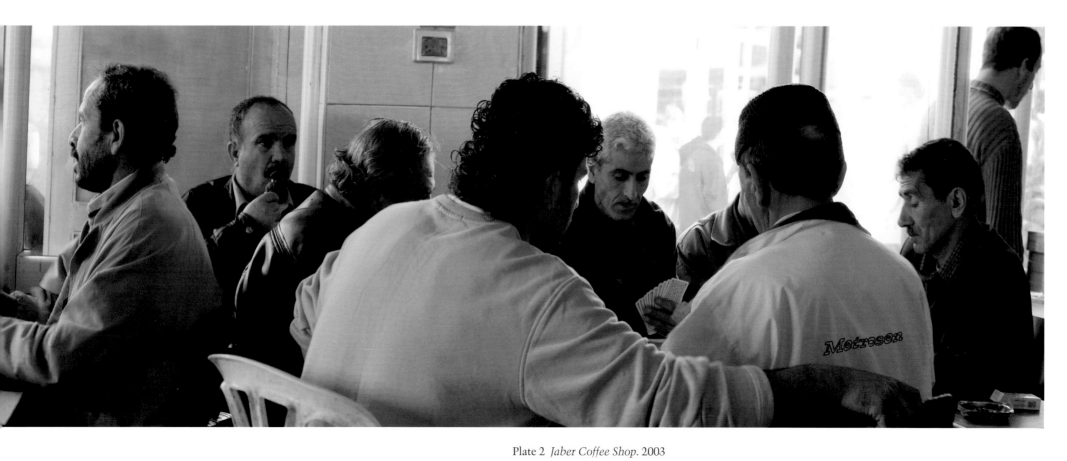

Plate 2 *Jaber Coffee Shop.* 2003

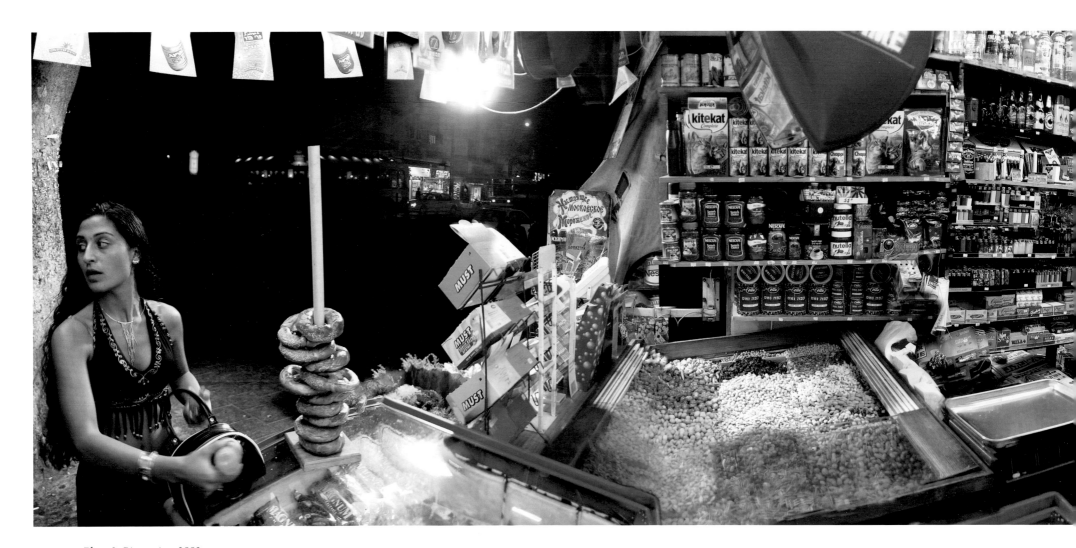

Plate 3 *Pitzutziya*. 2002

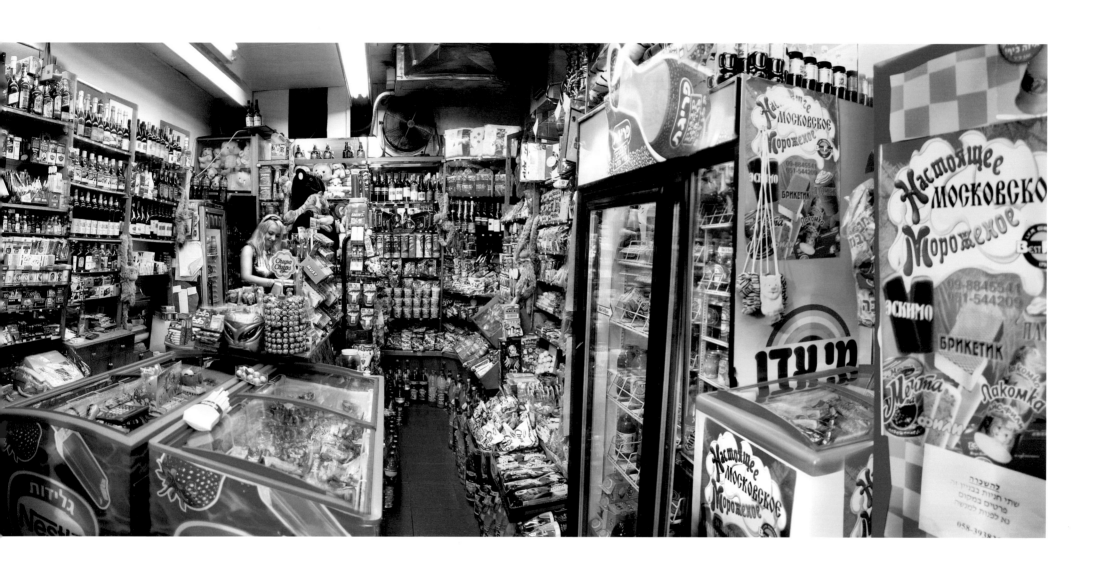

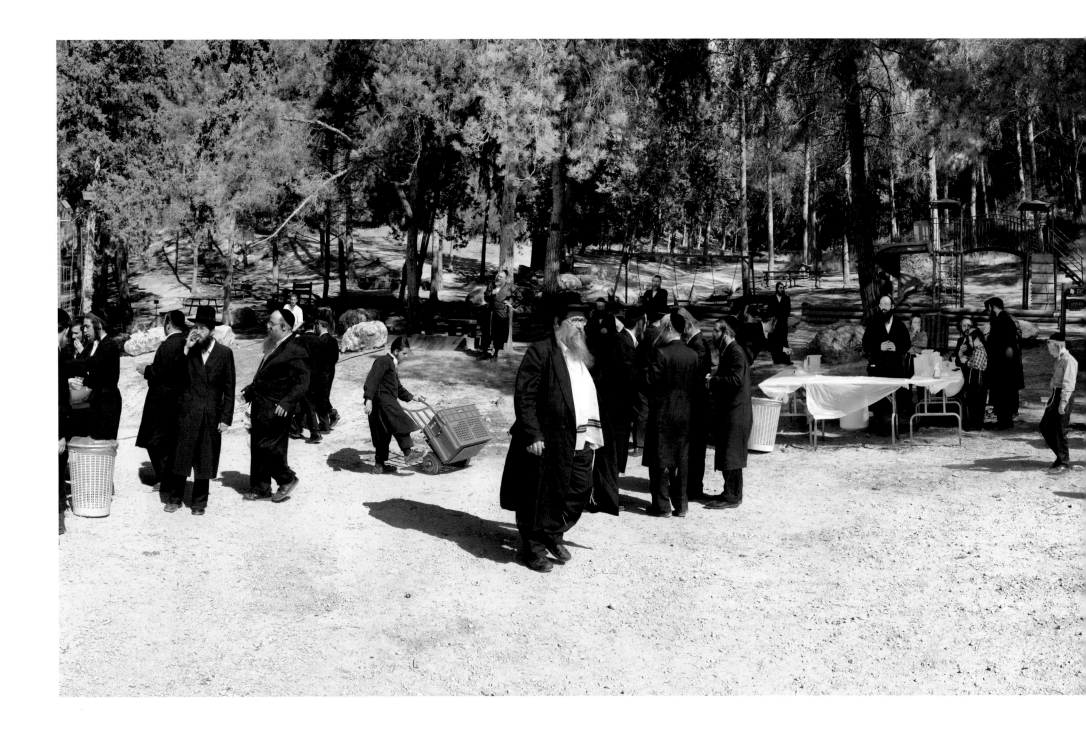

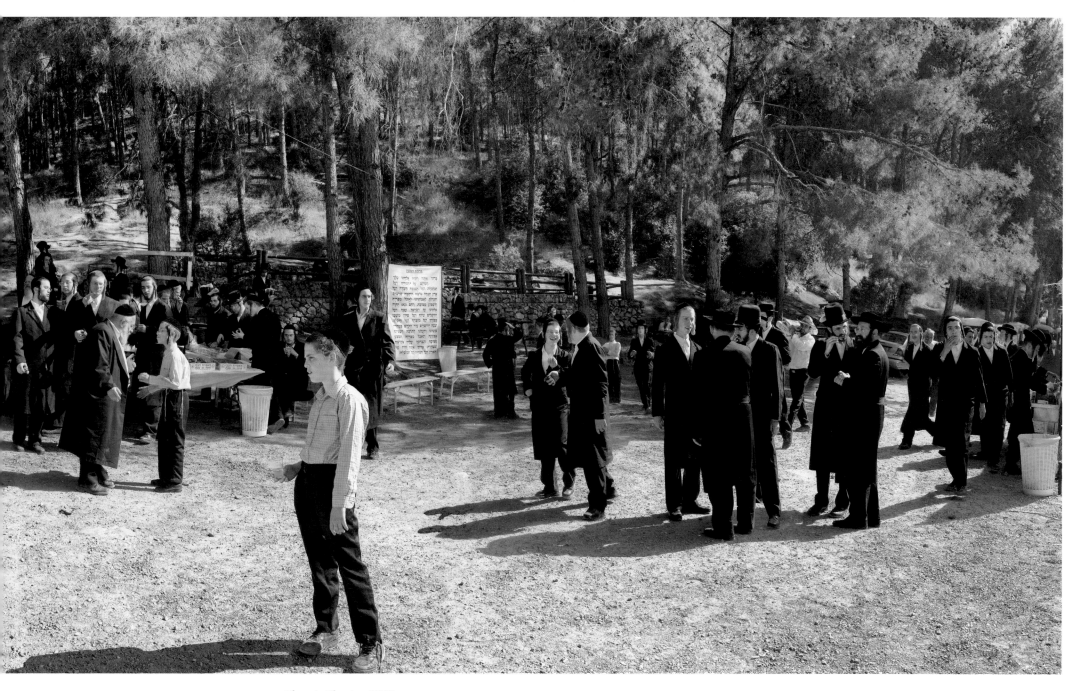

Plate 4 *Blessing.* 2005

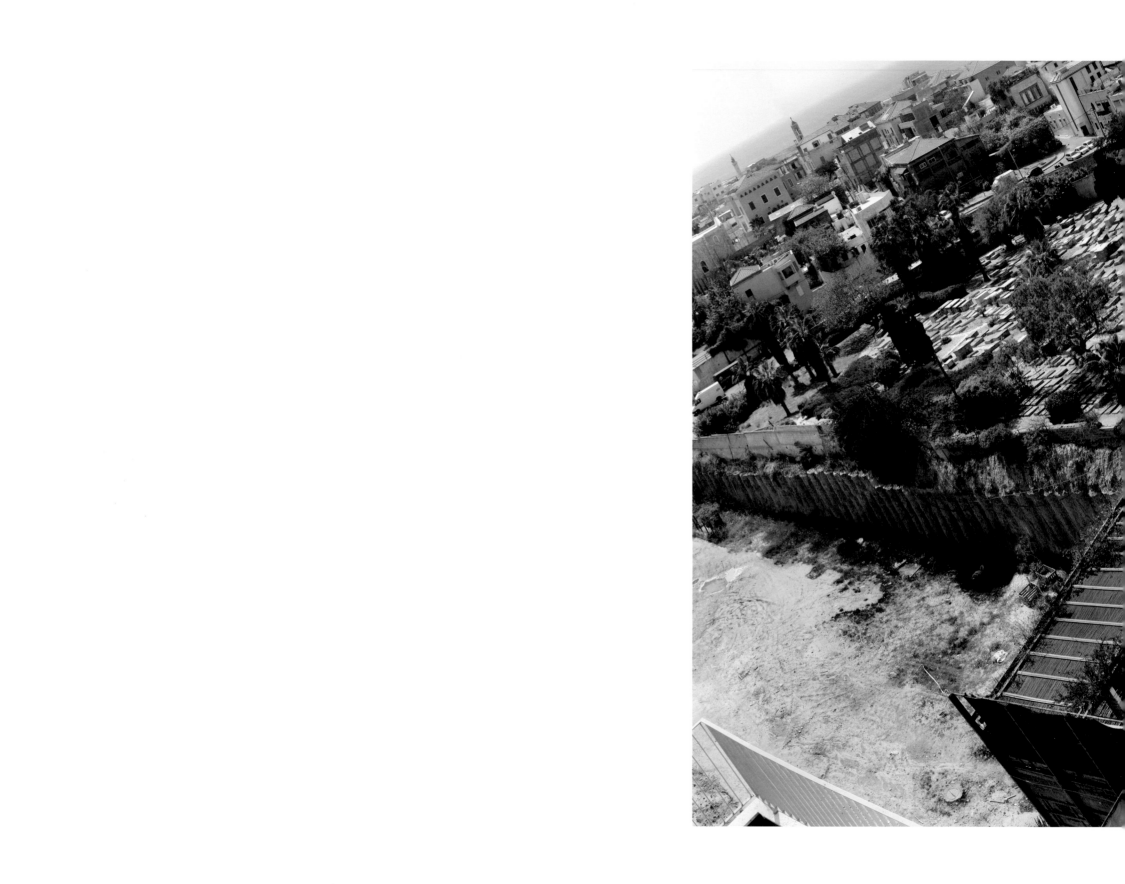

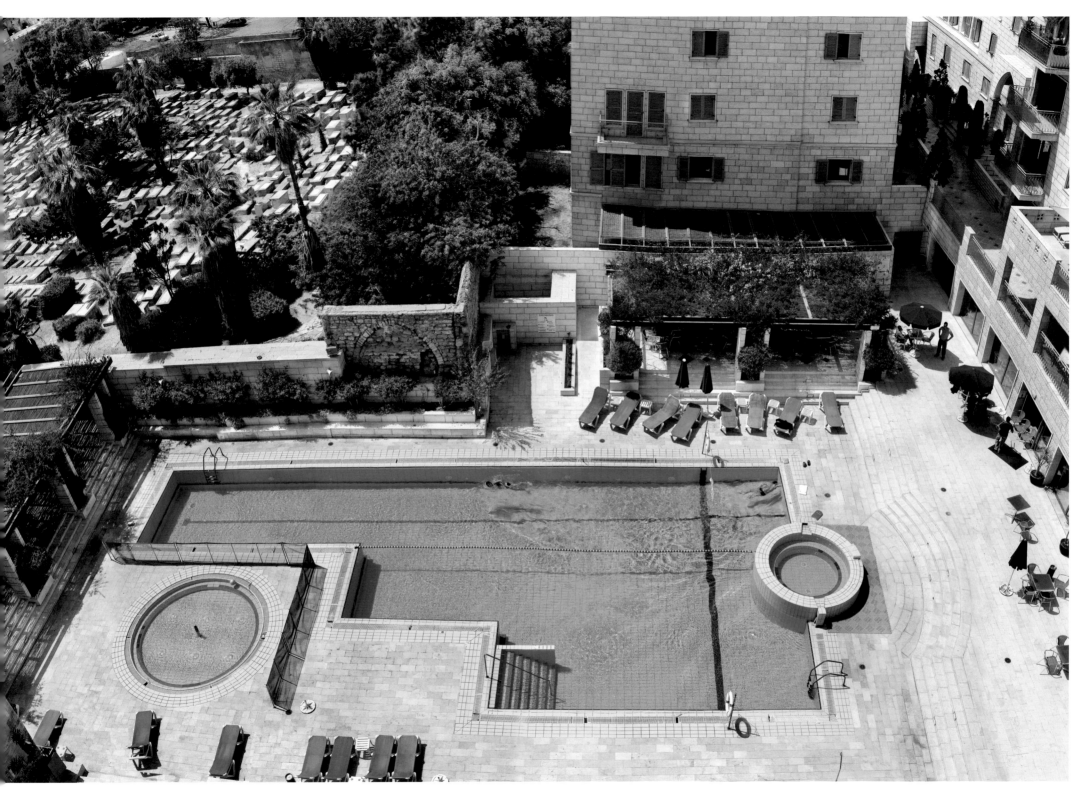

Plate 5 *Estates*. 2005

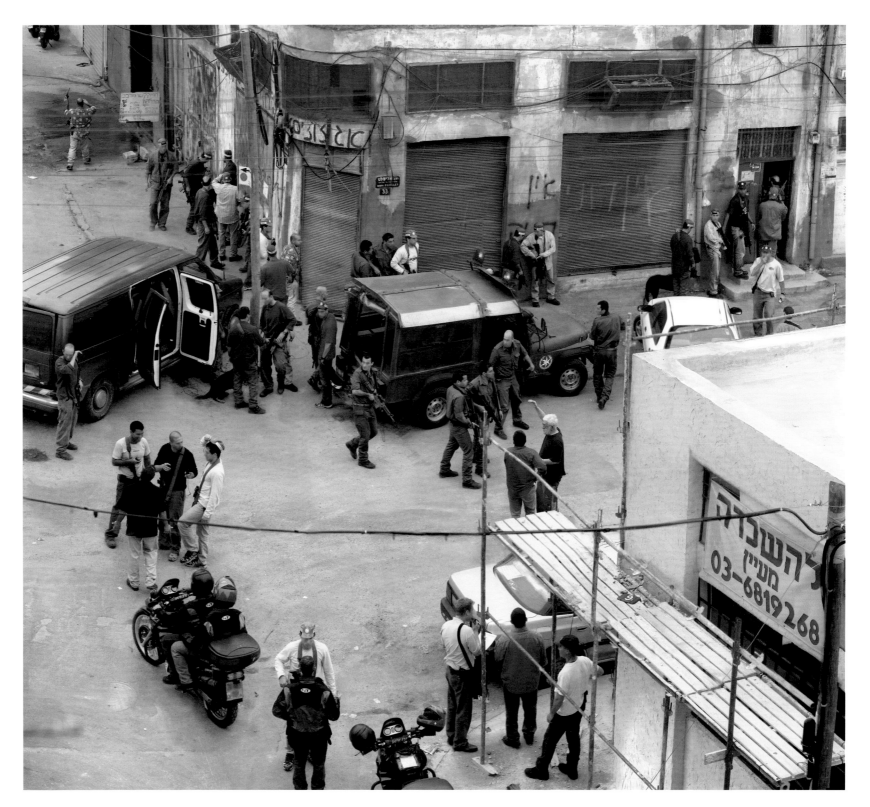

Plate 6 *Raid*. 2003

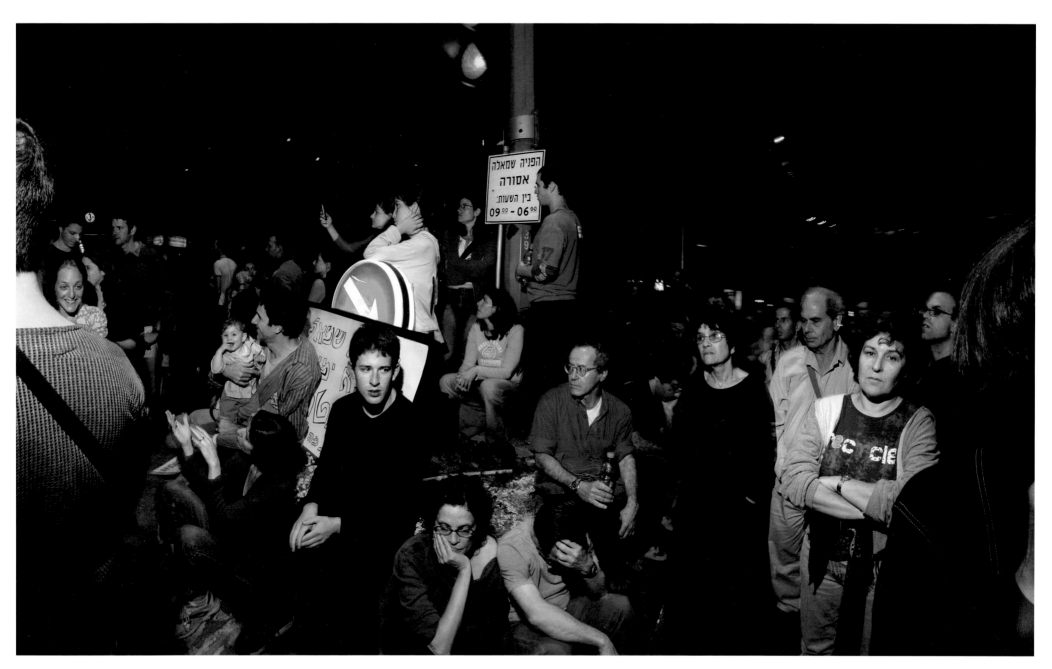

Plate 7 *Last Peace Demonstration*. 2003

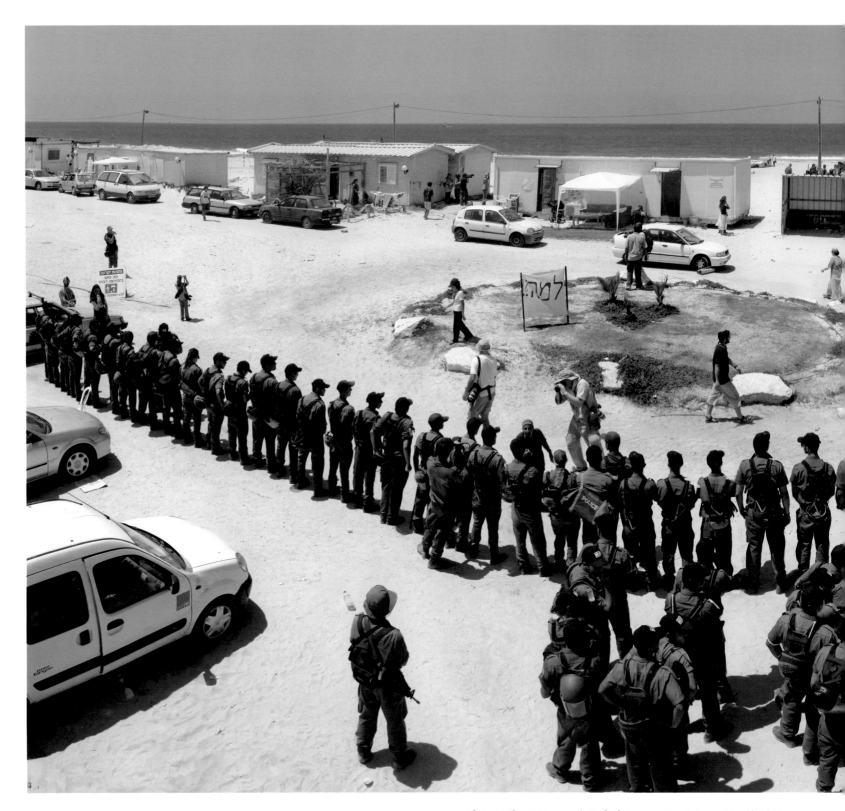

Plate 8 *Shirat Hayam ("End of Occupation?" Series No. 2).* 2005

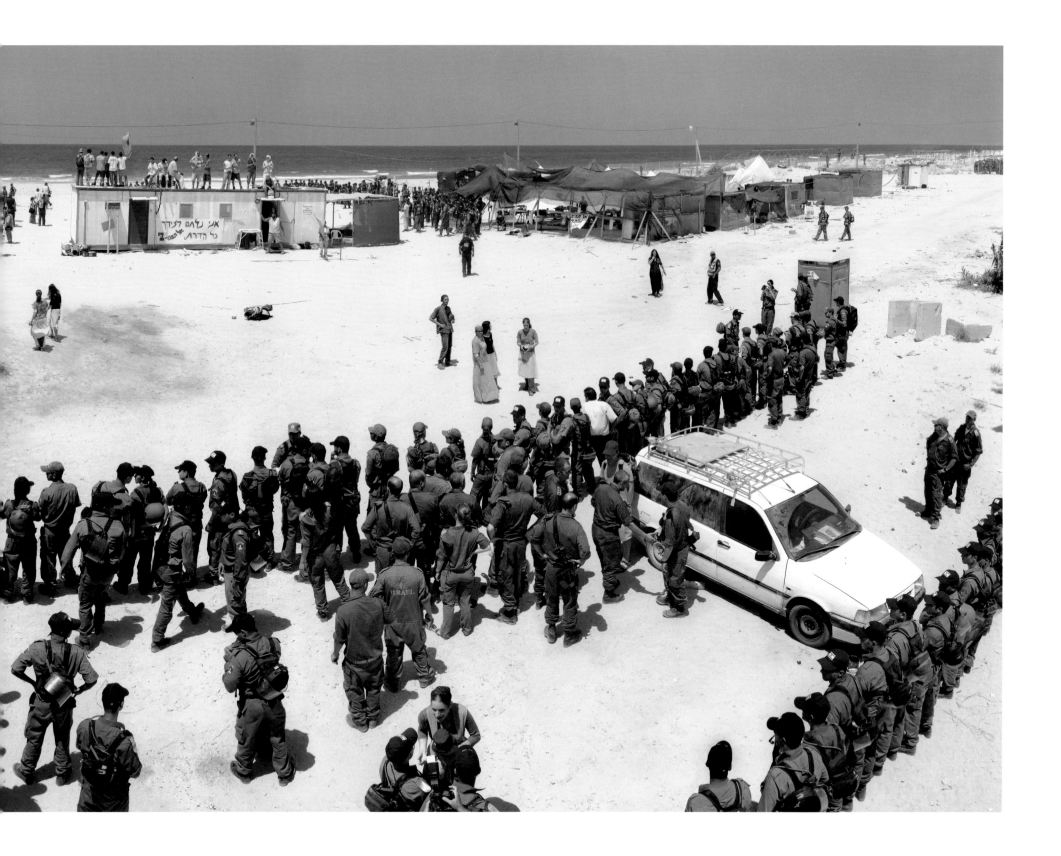

Plate 9 *Waiting ("End of Occupation?" Series No. 1)*. 2005

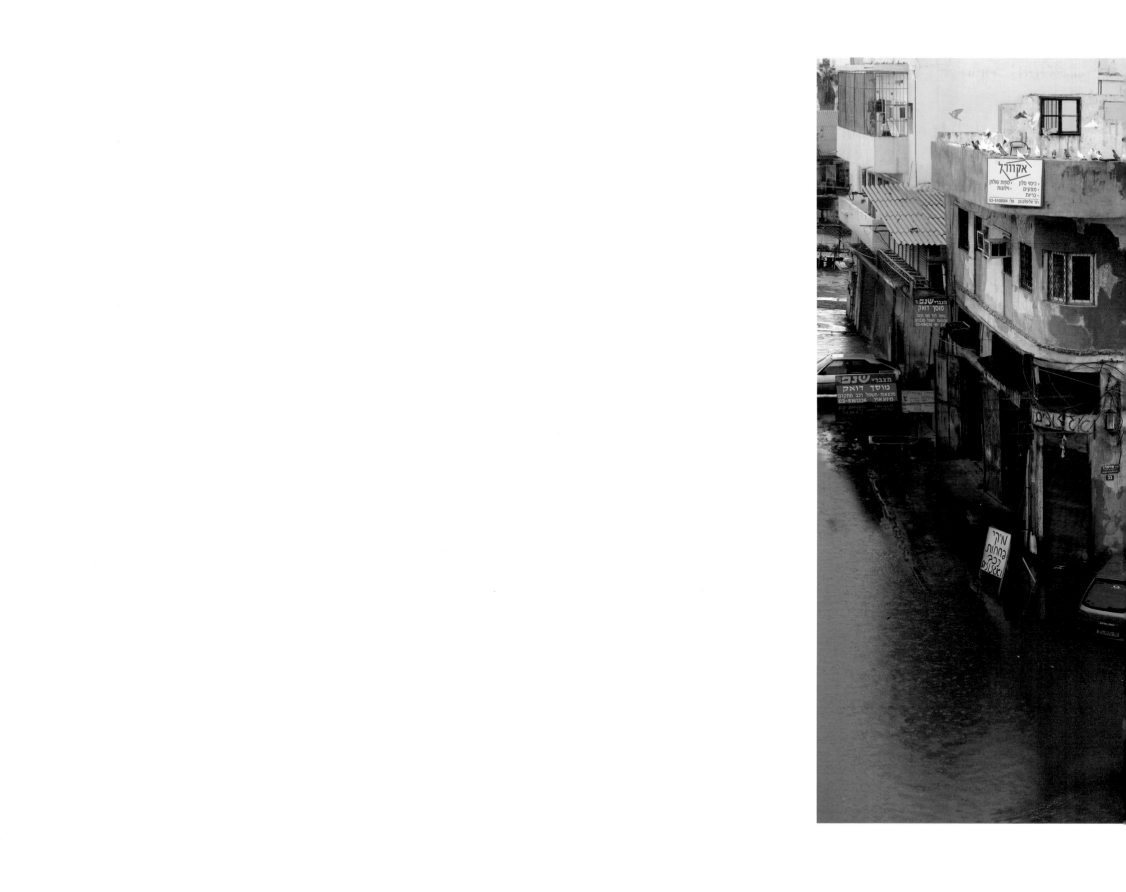

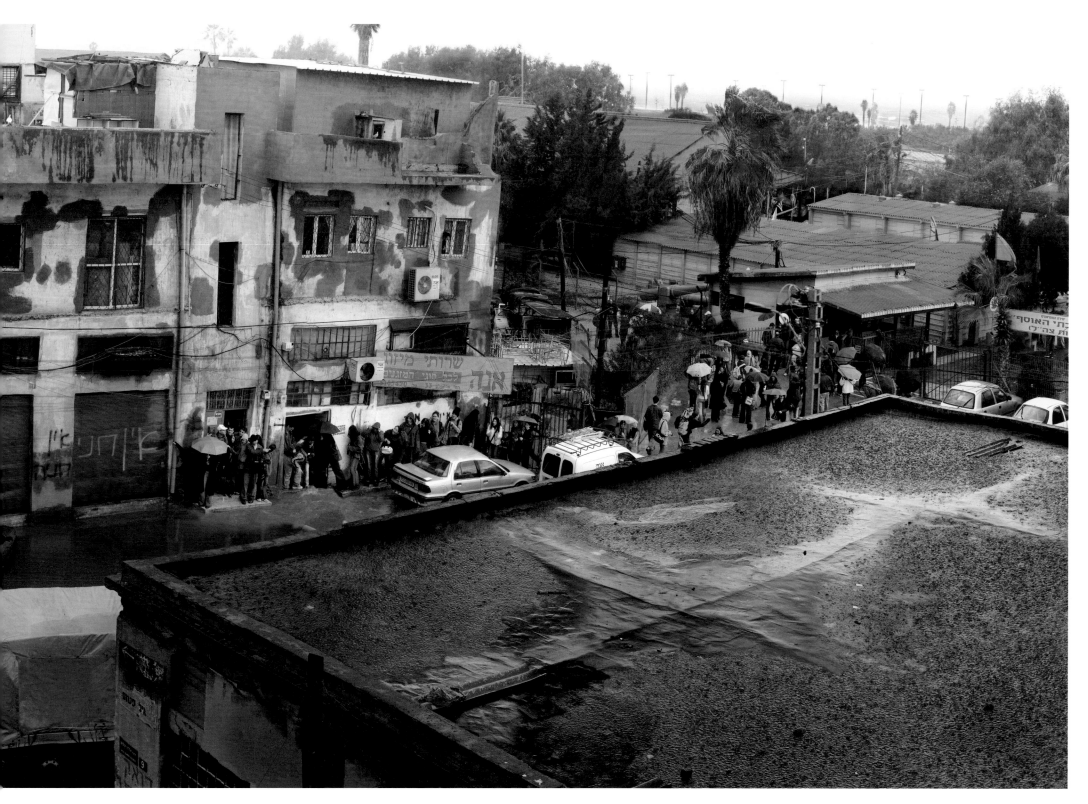

Plate 10 *Flood*. 2003

List of Plates

Plate 1
Friday. 2002
20 ½" x 71 ⅝" (52 x 182 cm)
Courtesy of the artist and Andrea Meislin Gallery,
New York

Plate 2
Jaber Coffee Shop. 2003
26 ¾" x 9' 1 ¹⁄₁₆" (68 x 277 cm)
Collection of Mirian and David Landau, New York

Plate 3
Pitzutziya. 2002
31 ⅛" x 9' ¹¹⁄₁₆" (79 x 276 cm)
Collection of Suzanne and Jacob Doft, New York

Plate 4
Blessing. 2005
57 ¹⁄₁₆" x 13' 8 ⅝" (145 x 413 cm)
The Museum of Modern Art, New York
Acquired through the generosity of Jo Carole and
Ronald S. Lauder

Plate 5
Estates. 2005
44 ⅛" x 7' 7 ⁹⁄₁₆" (112 x 230 cm)
Collection of Gale and Steven Spira, New York

Plate 6
Raid. 2003
50 x 58 ¹¹⁄₁₆" (127 x 149 cm)
Collection of Mirian and David Landau,
New York

Plate 7
Last Peace Demonstration. 2003
50" x 6' 6 ¾" (127 x 200 cm)
Courtesy of the artist and Andrea Meislin Gallery,
New York

Plate 8
Shirat Hayam ("End of Occupation!" Series No. 2).
2005
59 ¹⁄₁₆" x 10' 10 ¹¹⁄₁₆" (150 x 332 cm)
Courtesy of the artist and Andrea Meislin Gallery,
New York

Plate 9
Waiting ("End of Occupation!" Series No. 1). 2005
32 ¹¹⁄₁₆" x 10' 10 ¹¹⁄₁₆" (83 x 332 cm)
Courtesy of the artist and Andrea Meislin Gallery,
New York

Plate 10
Flood. 2003
49 ³⁄₁₆" x 7' 10" (124.9 x 238.8 cm)
The Museum of Modern Art, New York
Acquired through the generosity of Harriette Levine

All of the works are chromogenic color prints.

Exhibition Chronology and Bibliography

Barry Frydlender was born in Tel Aviv, Israel, in 1954 and studied film and television at Tel Aviv University from 1976 to 1980.

ONE-PERSON EXHIBITIONS

2007
Barry Frydlender: Down Here. Tel Aviv Museum of
Art, Tel Aviv

2006
New Work. Andrea Meislin Gallery, New York

2005
Rencontres internationales de la photographie,
Arles, France

2004
The Fourth Dimension. Andrea Meislin Gallery,
New York

1987
Photographs 1982–1987. Photography Center of Athens,
Athens

1985
Café Kassit. The Israel Museum, Jerusalem

1983
Café Kassit. Nikon Gallery, London

GROUP EXHIBITIONS

2007
Dateline Israel: New Photography and Video Art.
The Jewish Museum, New York

2006
*Art of Living: Contemporary Photography and Video
from the Israel Museum*. The Contemporary
Jewish Museum, San Francisco
Disengagement. Tel Aviv Museum of Art, Tel Aviv

2005

New Work / New Acquisitions. The Museum of
Modern Art, New York

Chaim Life: Israel through the Photographer's Lens.
The Laurie M. Tisch Gallery, The Jewish
Community Center, New York

The New Hebrews: A Century of Art in Israel.
Martin-Gropius Bau, Berlin. Organized by The
Israel Museum, Jerusalem

2004

Current Visions. Andrea Meislin Gallery, New York

Water, Water Everywhere. Andrea Meislin Gallery,
New York

2003

Here and Elsewhere. Passage de Retz, Paris

Youth Love. Riding Power Station, Tel Aviv

*Young Israeli Art: The Jacques and Eugenie O'Hana
Collection*, Tel Aviv Museum of Art, Tel Aviv

Public Space. Tel Aviv Museum of Art, Tel Aviv

2002

Chilufim: Exchange of Artists and Art. The Israel
Museum, Jerusalem; Herzliya Museum of Art;
Kunstmuseum Bonn; Kaiser Wilhelm Museum,
Krefeld; Museum am Ostwall, Dortmund

Explora Digital Art. Kalisher Gallery, Tel Aviv

2001

Tel Aviv-Berlin: New Media Experience. Novalog,
Berlin

1999

Urban Landscape. Tel Aviv Museum of Art, Tel Aviv

1998

Double Rivage. Centre régional d'art contemporain,
Sète, France

After Rabin: New Art From Israel. The Jewish
Museum, New York

4 Artistes. Le Quartier, Centre régional d'art
contemporain de Quimper, France

Mad Media. Arad Museum, Arad, Israel

1997

Ainsi de suite. Centre régional d'art contemporain,
Sète, France

A Delicate Balance. The Light Factory Gallery,
Charlotte, North Carolina

1994

Black Holes: The White Locus. International Biennale
of São Paulo, São Paulo, Brazil. Shown in 1996 at
the Haifa Museum, Haifa, Israel

Anxiety. Ramat Gan Museum of Israeli Art,
Ramat Gan, Israel

Art Focus. The Israel Museum, Jerusalem

1991

New Acquisitions. Tel Aviv Museum of Art, Tel Aviv

Patterns of Jewish Life. Martin-Gropius-Bau, Berlin

1989

Warm Light. Helsinki Museum of Photography,
Helsinki, Finland

1987

City Light. Art Gallery, Goldsmith College, University
of London

1986

The Israeli Photography Biennial, Museum of Art,
Ein Harod, Israel

1985

De la bible à nos jours: 3000 ans d'art. Grand Palais,
Paris

1982

Floods of Light. Photographers Gallery, London

EXHIBITION CATALOGUES

Barry Frydlender: Café Kassit—Photographs. Jerusalem:
The Israel Museum, 1985. Text: Nissan N. Perez,
"Barry Frydlender's Café Kassit: A Myth and a
Tradition." In English and Hebrew.

Barry Frydlender: Down Here. Tel Aviv: Tel Aviv Museum
of Art, 2007. Texts: Moshe Ninio, "The Decided
Moment: Patched Tales," and Zvi Szir, "Digital
Proximities." In English and Hebrew.

Dateline Israel: New Photography and Video Art.
New York: The Jewish Museum, 2007. Texts: Andy
Grundberg, "Beyond Boundaries, Within Borders";
Nissan N. Perez, "Concerning Life in Israel"; and
Susan Tumarkin Goodman, "A Matter of Place."

ARTICLES, ESSAYS, AND REVIEWS

Aletti, Vince. "An Israeli Photographer and His Panoramic
Time Machines." *The Village Voice*, September 15–21,
2004, p. 94.

_____. "Barry Frydlender." *The New Yorker*, May 8,
2006, p. 14.

Baqué, Dominique. "Ici, la-bas et ailleurs." *Artpress*, no. 297
(January 2004): 90.

Camhi, Leslie. "Life in the Unholy Holy Land."
The Forward, October 1, 2004, pp. 12–13.

_____. "Multiple Perspectives." *The Village Voice*, April
19–25, 2006, p. 72.

Frankel, Stephen Robert. "Barry Frydlender at Andrea
Meislin Gallery." *Art on Paper* 9, no. 2 (November/
December 2004): 81–82.

Grosz, David. "Hard Lines and Gentle Curves." *The New
York Sun*, *Arts and Letters*, April 27, 2006, p. 24.

Leffingwell, Edward. "Barry Frydlender at Andrea Meislin."
Art in America 92, no. 9 (April 2005): 154.

Wolinski, Natacha. "Photo Reportage." *Beaux Arts maga-
zine*, no. 25 (November 2005): 78–79.

Woodward, Richard B. "Reality Bytes." *ARTnews* 104, no. 2
(February 2005): 108–11.

_____. "Altered States." *ARTnews* 105, no. 3 (March
2006): 104–09.

Details of plate 1

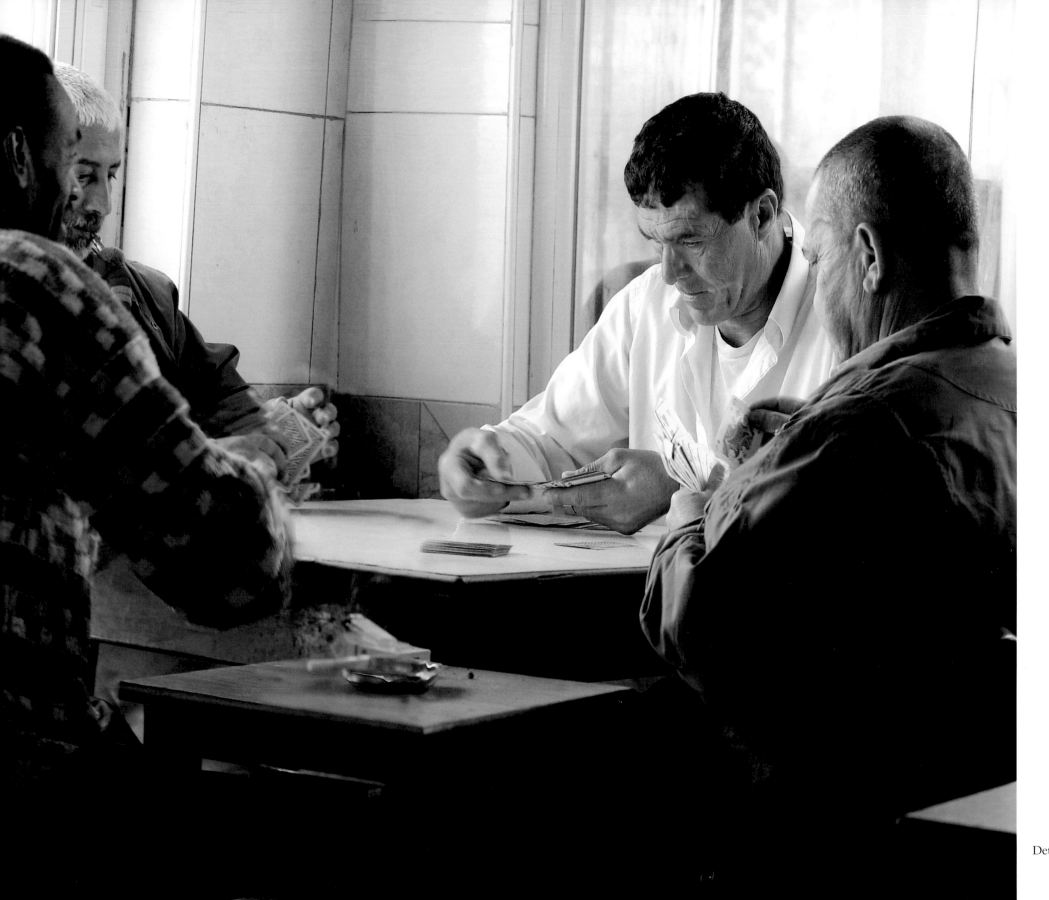

Details of plate 2

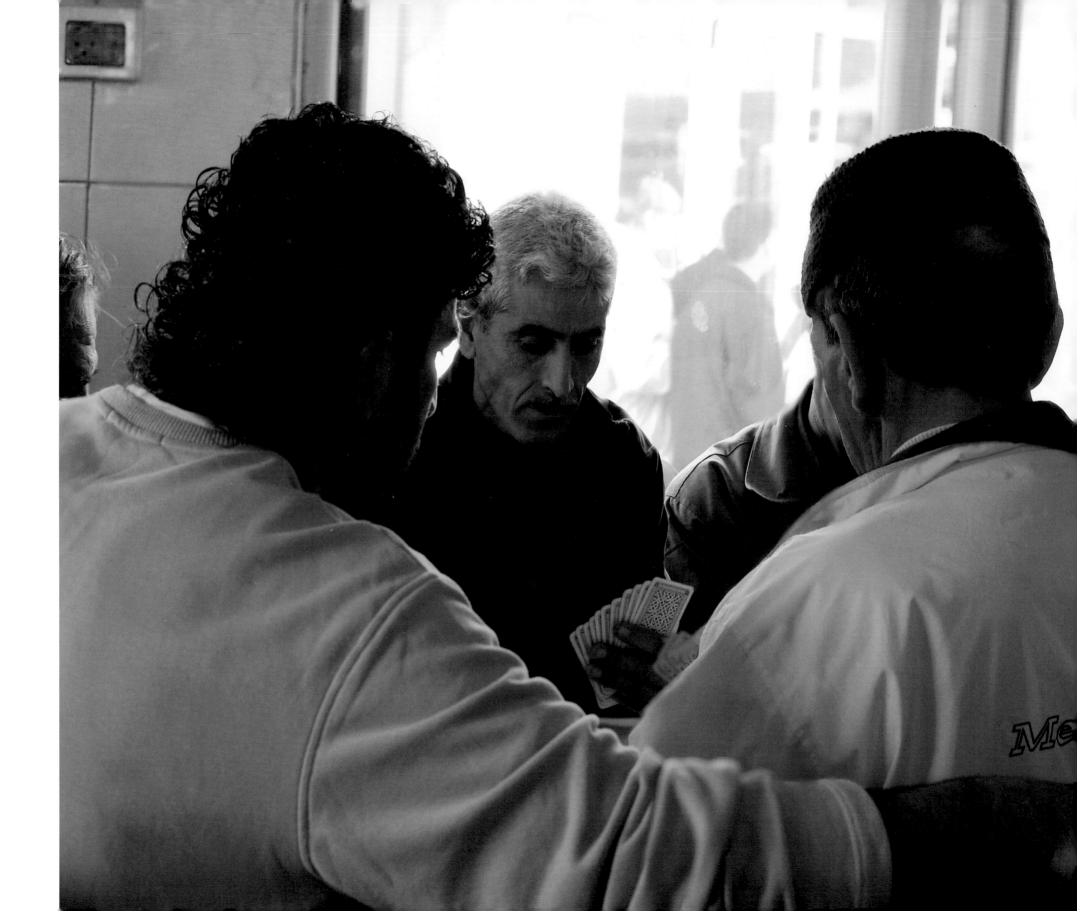

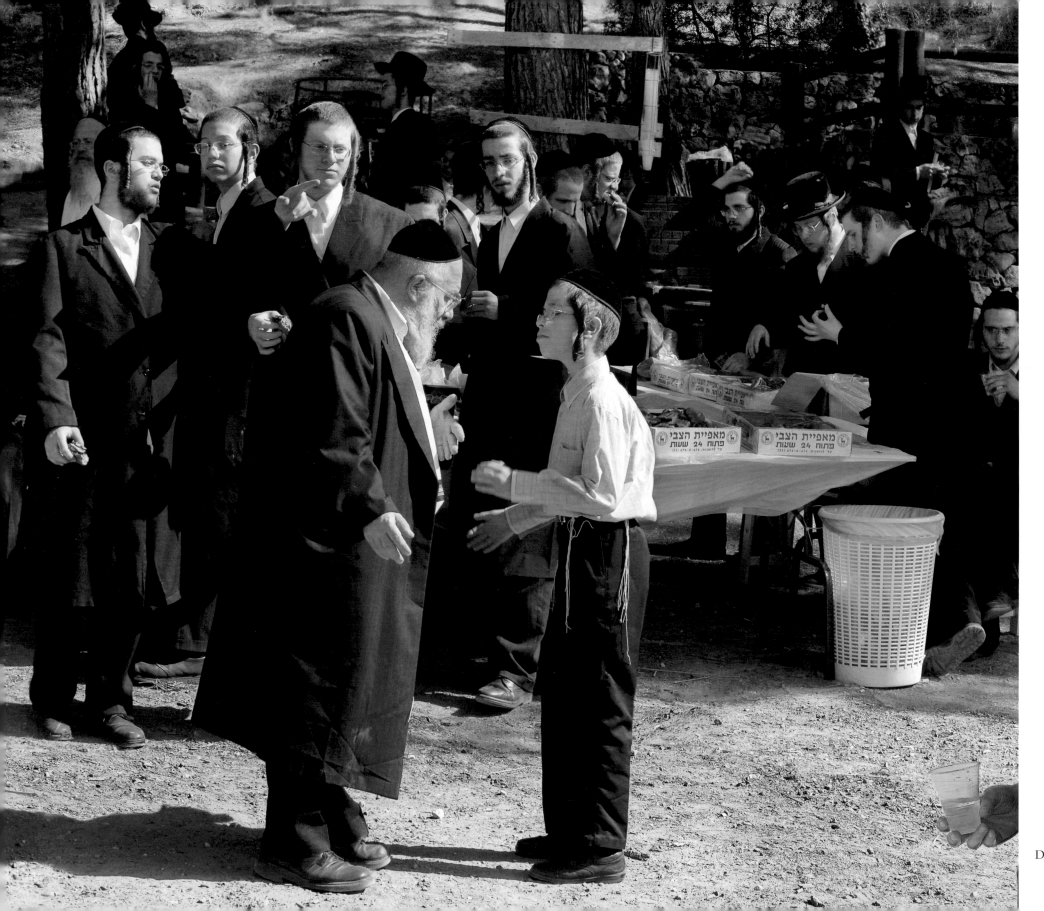

Details of plate 4

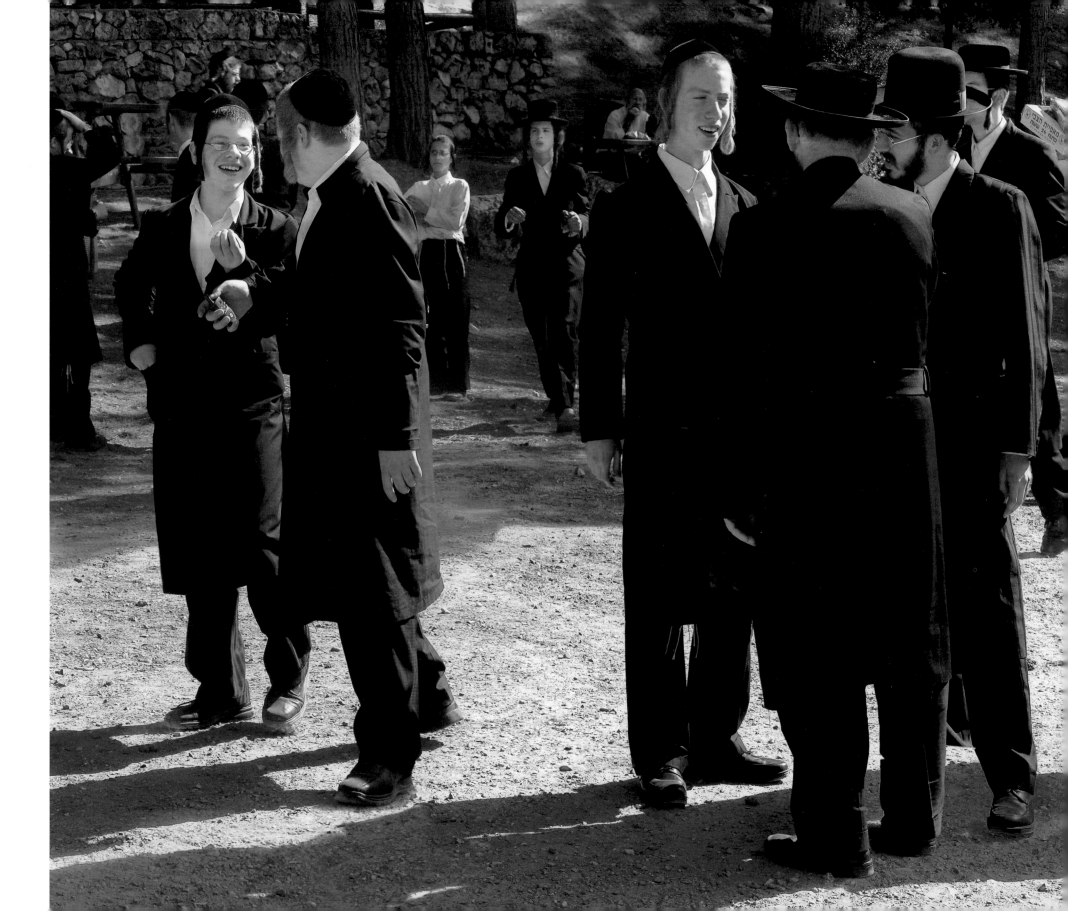

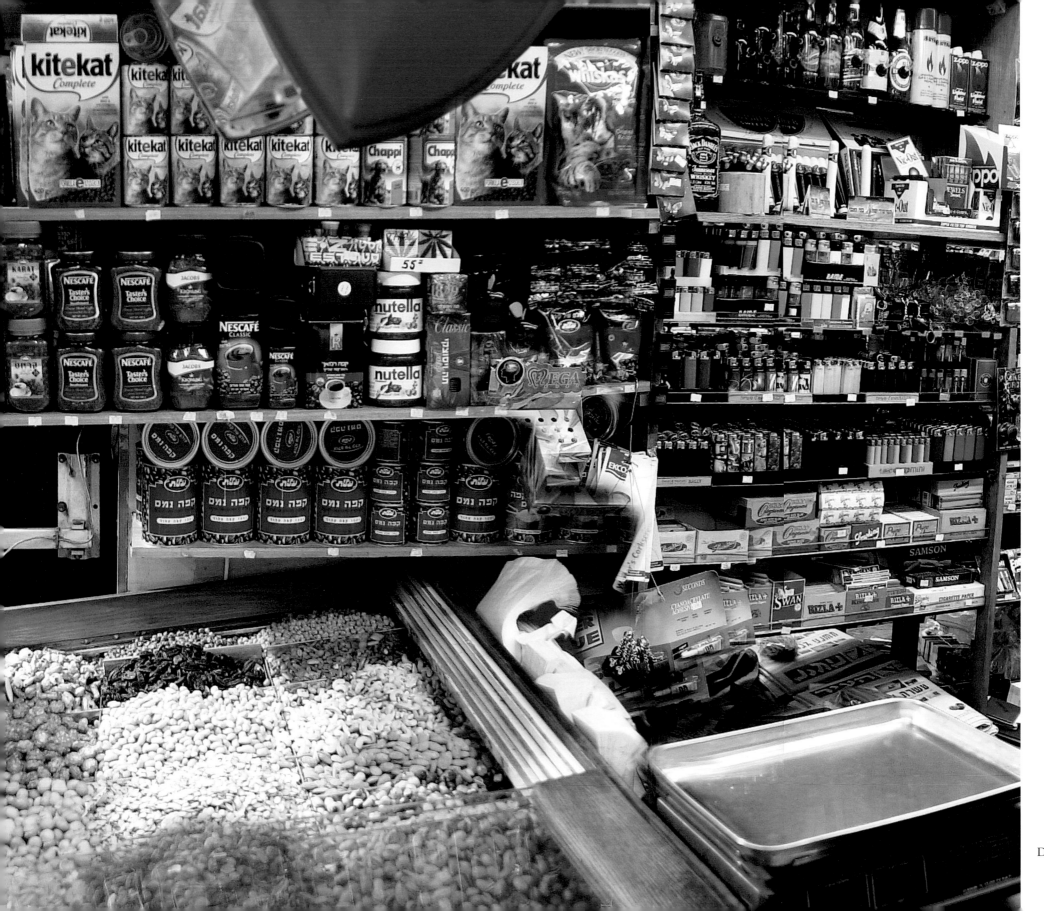

Detail of plate 3

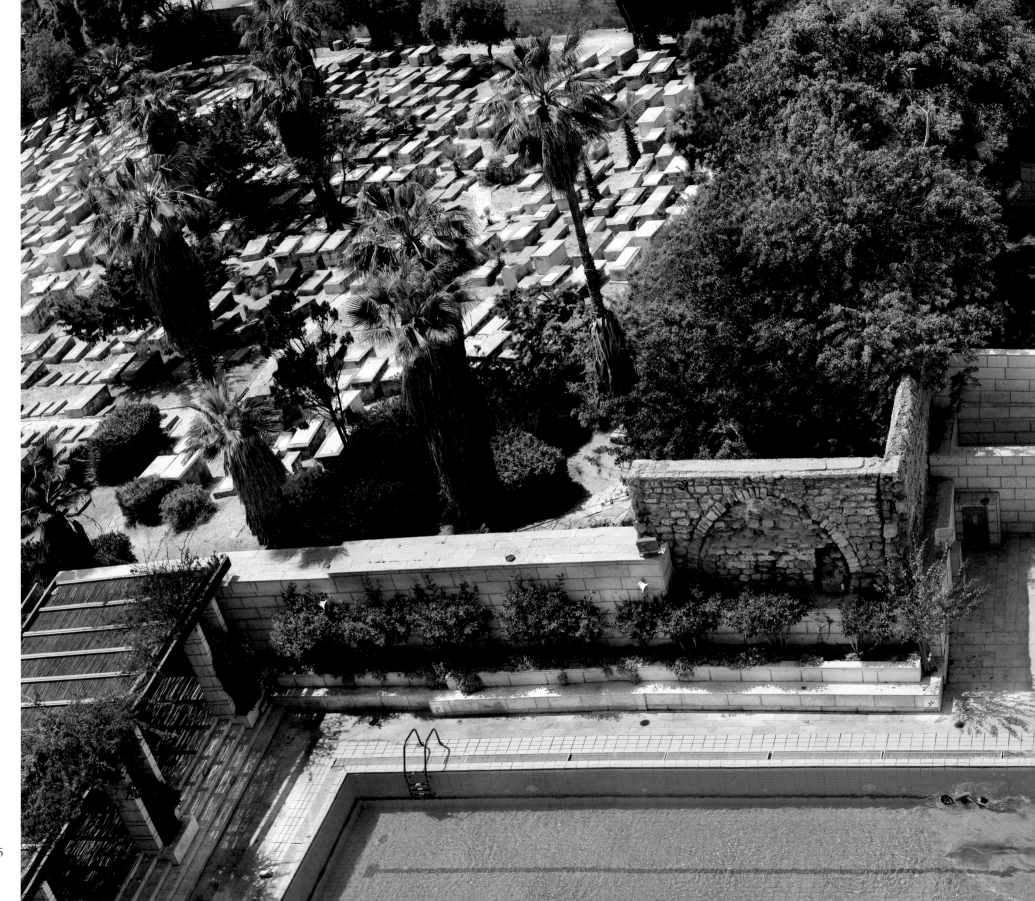

Detail of plate 5

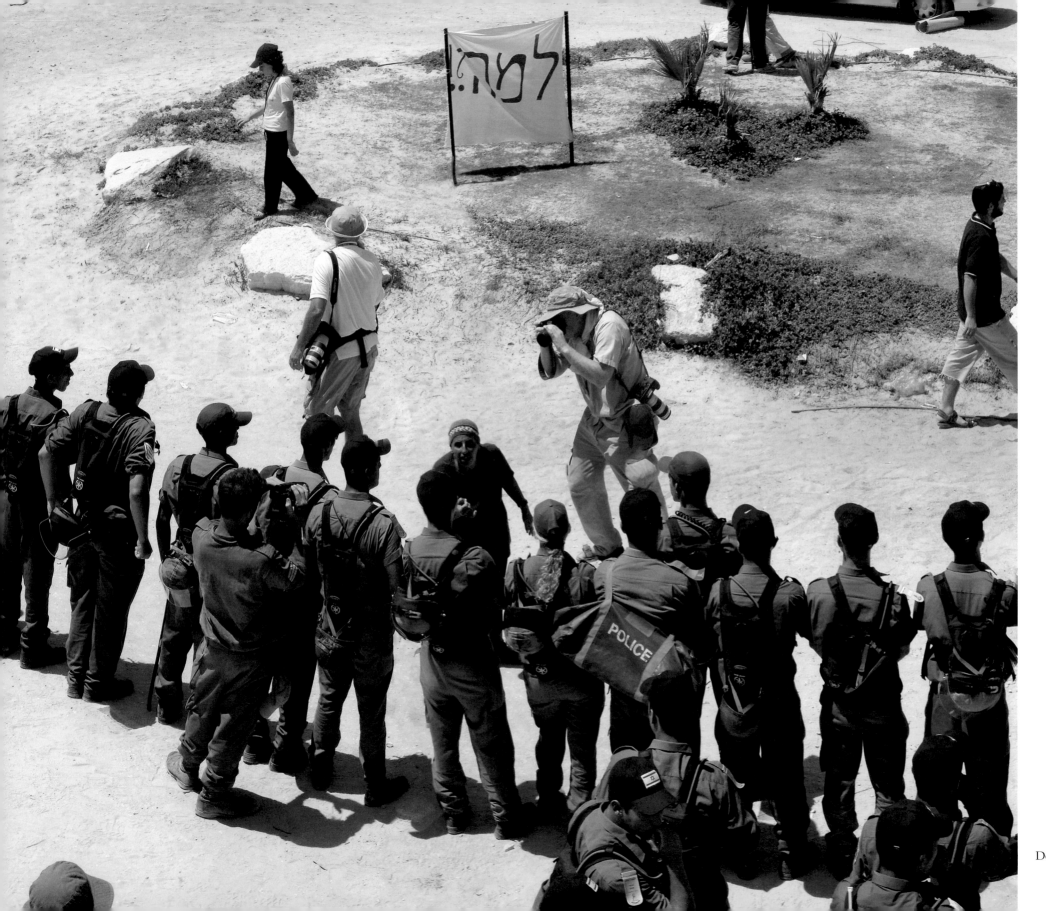

Details of plate 8

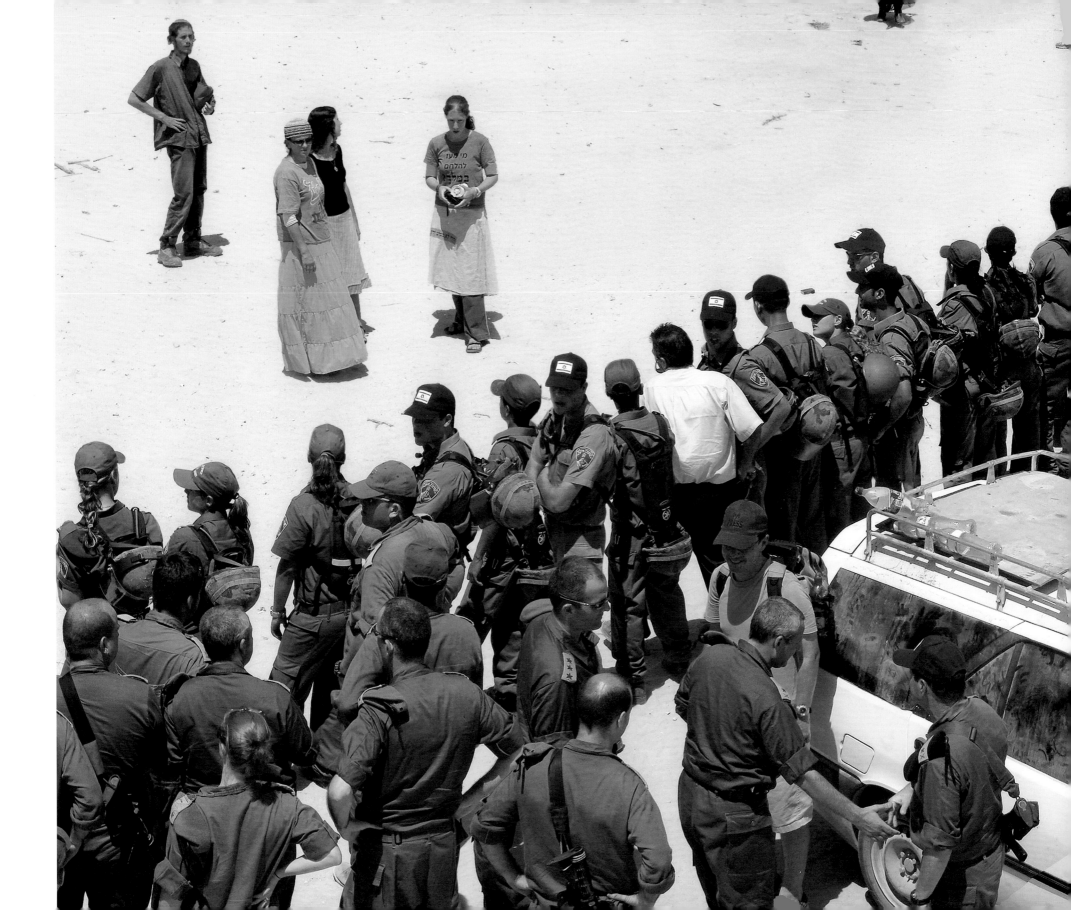

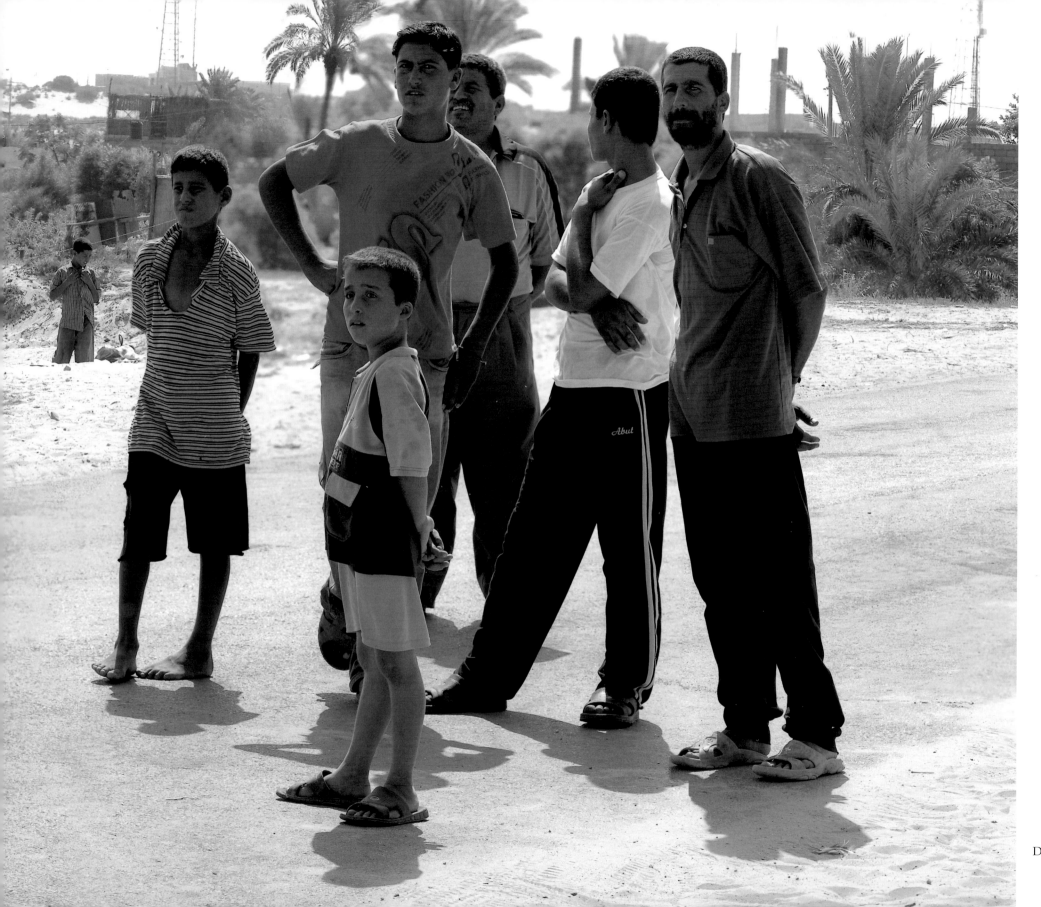

Details of plate 9

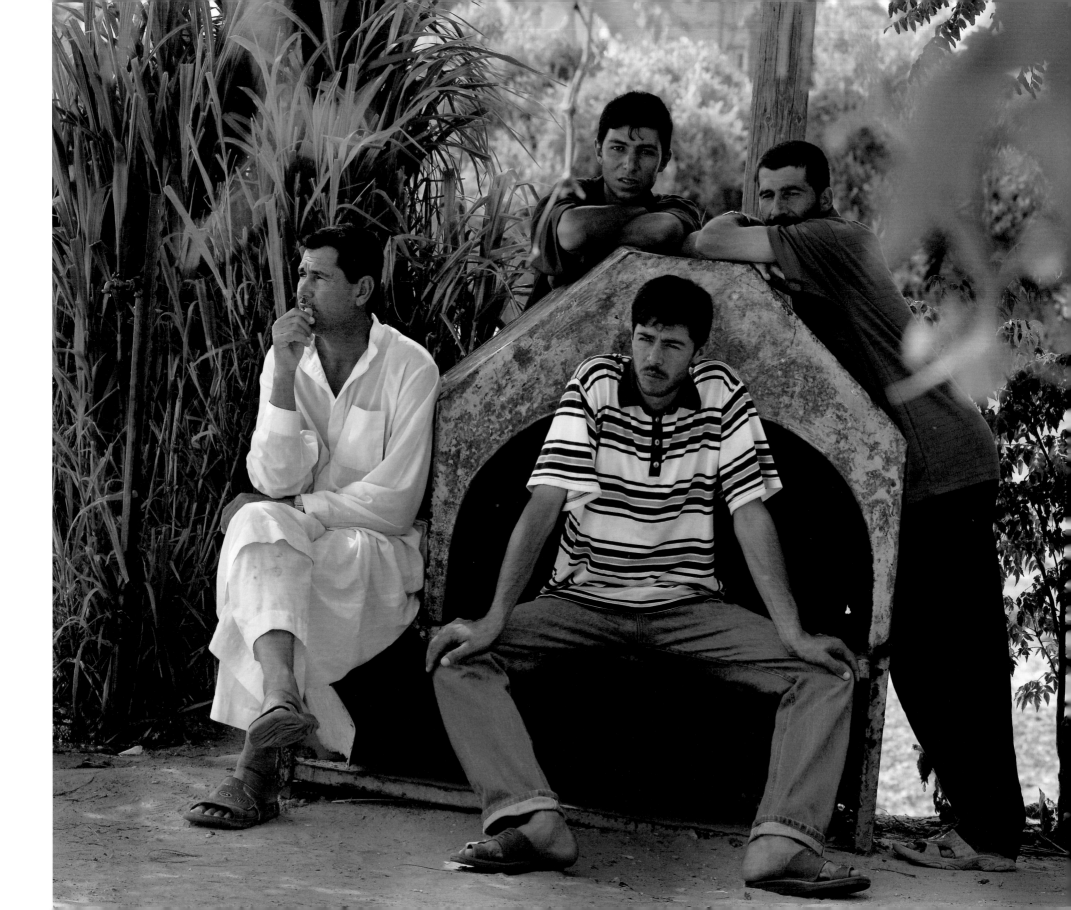

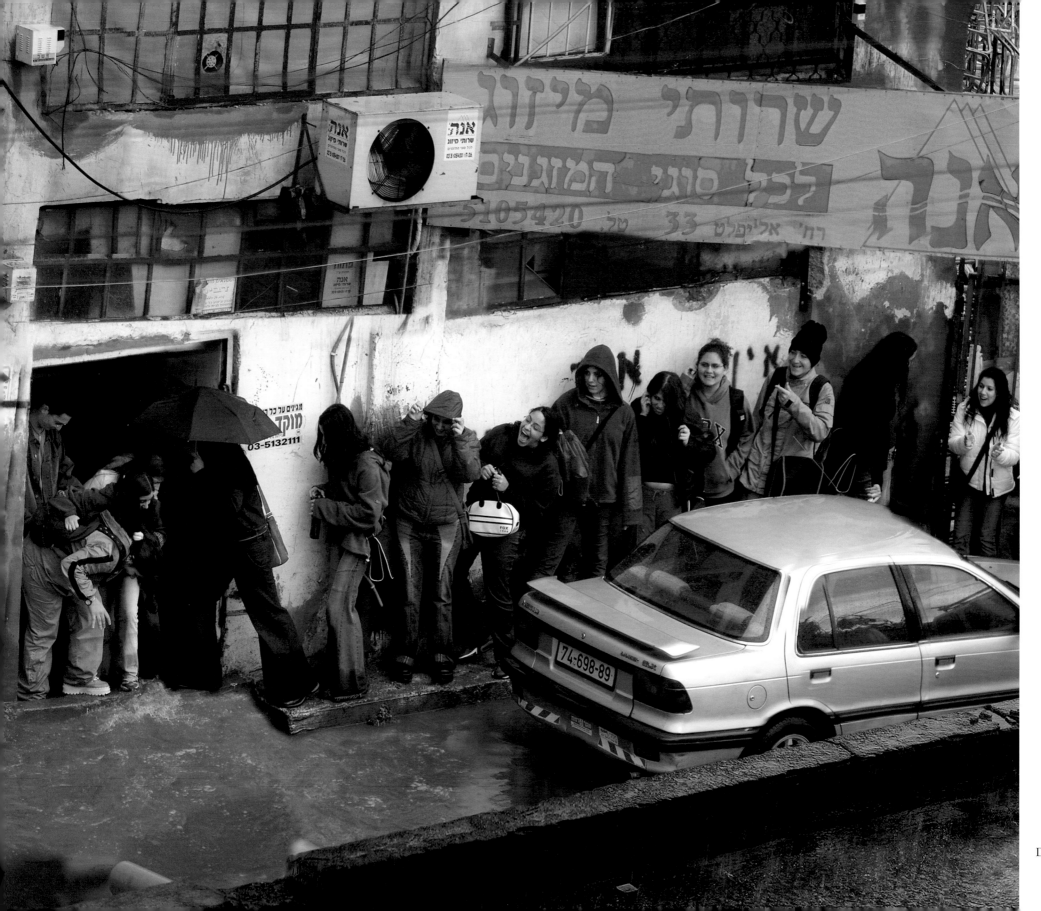

Details of plate 10

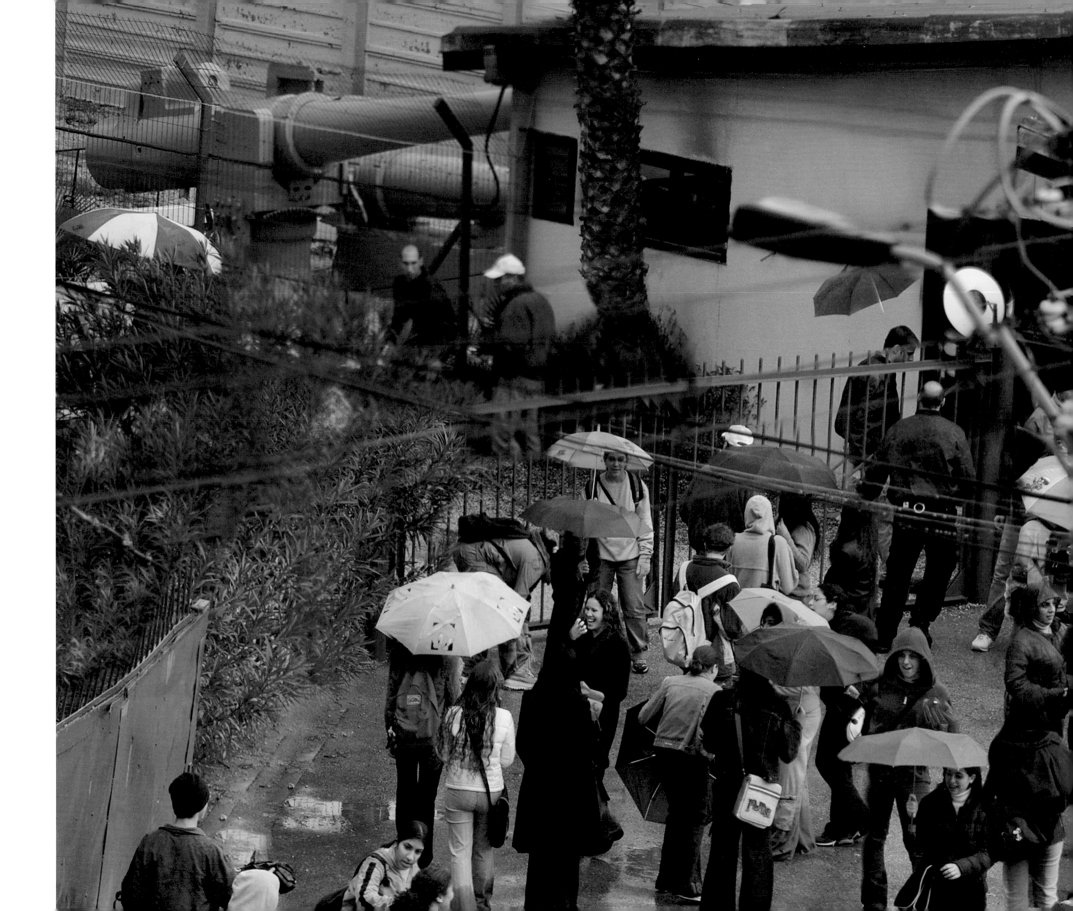

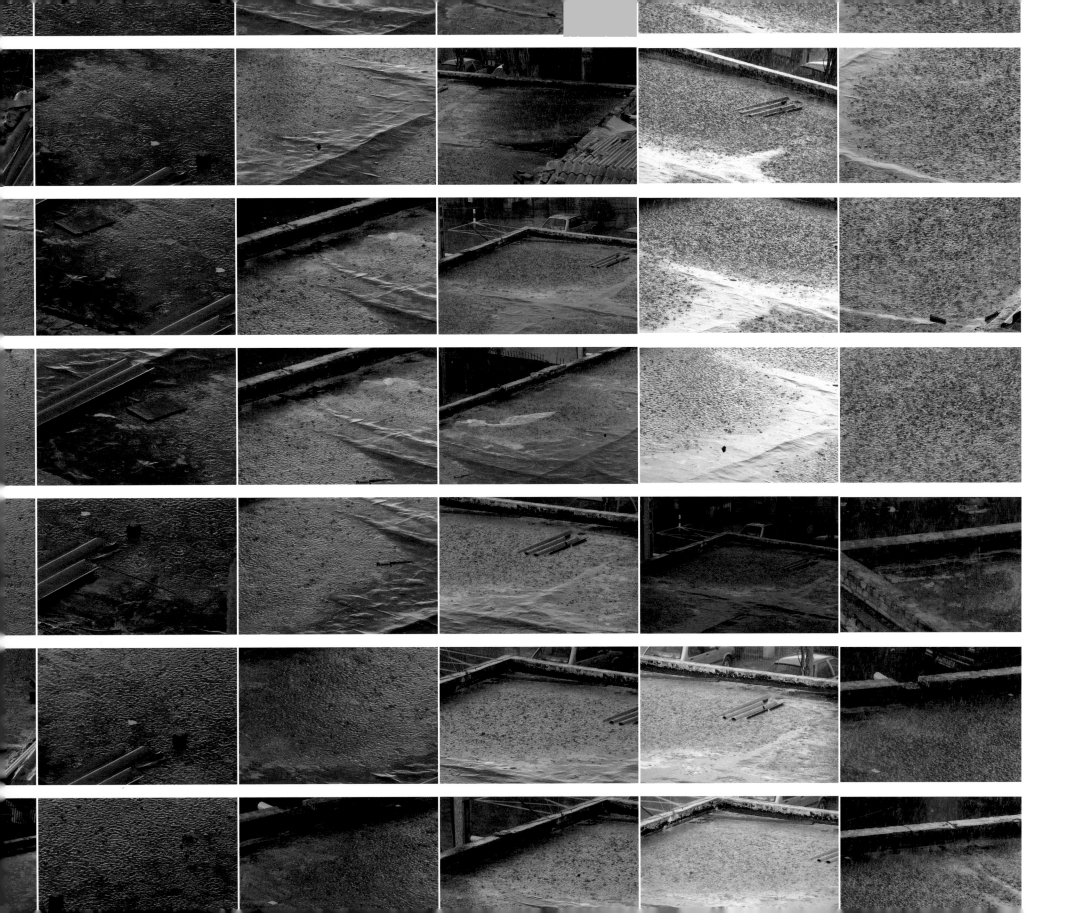

Afterword by Peter Galassi

Each of Barry Frydlender's large photographs is stitched together from dozens, sometimes hundreds, of discrete shots that may have taken minutes or months to accumulate. Among the many precedents for this additive method are composites assembled from small photographs transmitted by the unmanned Surveyor III spacecraft from the surface of the moon (fig. 2). Created by NASA in 1967, two years before it sent a man to the moon, those artifacts look hopelessly primitive next to Frydlender's intricately detailed color pictures, thanks to the powerful digital technology that enables him to dissolve the fish-scale crudeness of overlapping images into a virtually seamless image.

 In conventional photography, enlarging an image progressively dilutes detail: the bigger the final print, the bigger the negative must be to yield the same degree of sharpness. A vital advantage of Frydlender's method is that, although he enjoys the ease and mobility offered by a small, handheld camera, he can produce prints that are both large and sharp because each exposure contributes only a small portion of the final image. Those exposures, of course, are not film negatives but computer-ready digital files, each of which the photographer is able to review the instant after he has recorded it.

 A potential disadvantage of this method stems from the time it takes to harvest enough raw material for a big picture. If figures move during the process, for example, they may appear more than once in the final image. Here again there are precedents, such as panoramas produced by cameras with rotating lenses, which for a century or more have permitted a single person to pop up at both ends of a group photo by racing behind the camera as it slowly pans the scene. Also relevant are David Hockney's piecemeal pictures, which deftly register the passage of time as well as the dimensionality of space (fig. 3).

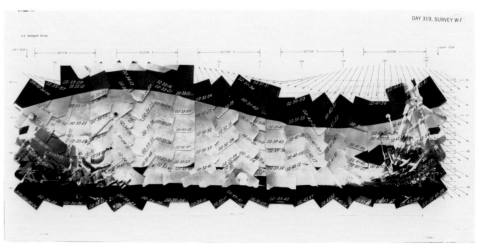

Opposite: Fig 1. A small, unedited sample of the hundreds of digital frames that Frydlender used to compose *Flood* (2003; plate 10)

Fig. 2. U.S. Geological Survey and NASA, Surveyor III
Surface of the Moon, Day 319, W–F. 1967
Cut and stapled gelatin silver prints with ink and gouache on diazotype, 14 ¹/₂ x 30 ³/₈" (36.9 x 77.1 cm)
The Museum of Modern Art, New York
John Parkinson III Fund

The advent of digital technology radically enhanced the artistic potential of a picture that describes a unified swath of space without representing a uniform period of time. Frydlender has been exploring that potential for more than a decade—since 1994—and over the past five years his experiment has gathered appreciable momentum. This publication and the exhibition it accompanies concern only one aspect of that work. They omit a considerable amount of work made in England, Germany, Egypt, and the United States—much of which has little or nothing to do with politics or religion—to focus on pictures that address the circumstance of contemporary Israel.

"Photography divorced me." The remark, typical of the mildly wry and self-deprecating flavor of Frydlender's reflections, refers to the crisis he experienced in 1989. Born in Tel Aviv in 1954, he belongs to the first generation of native Israelis. After studying film and television, he worked as a photojournalist while pursuing his personal work—a familiar pattern. The crisis occurred during the first Palestinian Intifada (1987–93), when Frydlender realized that he and other leftist photojournalists had become collaborators with the rock-throwing protesters in the spectacle of manufactured news. He ultimately lost faith in the medium of photography itself and stopped making pictures altogether. He began again five years later when he recognized that computer composites could acknowledge their own artificiality—their inherent deceit—by incorporating evidence of the passage of time and thus of the process that produced them. For Frydlender, the potential disadvantage of his method is its saving grace.

It takes time for the viewer of one of Frydlender's photographs to see that it took time for him to make it, and if we haven't finished looking we can't yet have made up our minds about what the image might mean. All of his work solicits patience, but the invitation is especially pertinent to the pictures assembled here.

Most of Frydlender's photographs, at home as well as abroad, depict quite ordinary realities. But the question of what is or should be ordinary can be highly contentious—nowhere more so than in his part of the world. The descriptive precision of Frydlender's large photographs consequently sharpens a double edge: every detail at once enhances the documentary accuracy of the image and reinforces the power of its symbolism.

Consider in this light a picture that in one sense is an exception, for its subject is not ordinary at all (plate 8). Israel's unilateral disengagement from the Gaza Strip in August 2005 entailed the evacuation of all Jewish settlements there. Among the most militant resisters of the forced evacuation were the residents of Shirat Hayam, a seaside community of some twenty families that had been established less than five years earlier. Between August 15 and 18 (10 through 13 Menahem-Av 5765), as the Israeli authorities confronted and finally evicted the settlers, the photographer accumulated the hundreds of images that he would later merge into a sweeping panorama. Frydlender designated the picture No. 2 in his "End of Occupation?" series, which to date comprises only two works. No. 1, titled *Waiting*, pictures local Massoui Bedouin men and boys who observed the evacuation of Shirat Hayam from a short distance away (plate 9).

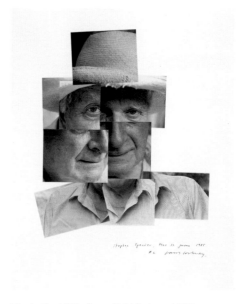

Fig. 3. David Hockney (British, born 1937) *Stephen Spender, Mas Saint-Jerome.* 1985 Chromogenic color prints, 15 13/16 x 13 9/16" (40.2 x 34.5 cm) The Museum of Modern Art, New York. The Fellows of Photography Fund

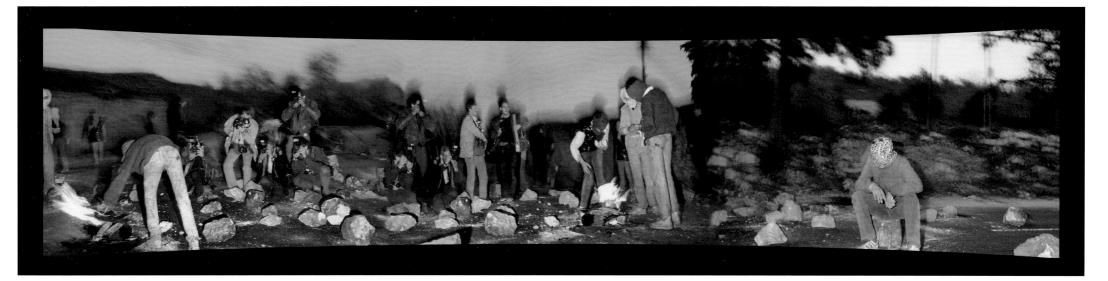

Fig. 4. Barry Frydlender. *Birth of a Nation*. 1998.
Chromogenic color transparency (Duratrans),
19 ¹¹/₁₆" x 6' 6 ¾" (50 x 200 cm). Courtesy of the artist

Frydlender shot the three frames that make up this image in 1989, during the first Palestinian Intifada. Nearly a decade later, he composed this digital montage. He has explained what is already evident in the image—that the photographers and the Palestinian protesters are collaborating to make pseudo-documentary pictures that will be useful to both groups. Although obviously ironic, the title of the picture is not cynical: Frydlender has pointed out that the creation and management of images is now a ubiquitous tool—and that the Palestinians' growing sophistication in using that tool has been a significant step toward their independence.

Part of the answer to the question posed by the title of Frydlender's series appeared in a front-page headline in the *New York Times* of December 27, 2006: "First Settlement In 10 Years Fuels Mideast Tensions." Among the few apparently uncontested facts reported in the story is that the thirty houses planned for the controversial West Bank site are to be occupied by the families of Shirat Hayam.

Although the seaside outpost existed as a Jewish settlement only for a short time, the identity of Shirat Hayam reaches back thousands of years, to the story of Exodus. Driven to the edge of the sea by Pharaoh's army, Moses and the Israelites were delivered when the waters parted to allow them to pass, then swiftly closed to drown the Egyptians. To anyone who knows that Shirat Hayam ("Song of the Sea") is the song that the Israelites sang in celebration of their deliverance, the simple structure of Frydlender's panorama—the police, the settlers, the sea—is highly charged. For the force that confronts Israelis at the edge of the sea is composed of other Israelis.

I had to look up the meaning of Shirat Hayam (an Internet search yielded reference to both the song and the Web site of the displaced settlers) but I was familiar with the biblical story evoked by another photograph, titled *Flood* (plate 10). Toward the upper-right corner of the image we can make out the entrance to the quasi-outdoor museum of the Israeli Defense Forces (IDF) and two of the big guns on display there. Most of the figures are high-school students on a ritual visit to the museum; in a short time they will face obligatory service in the IDF. The flat roof in the foreground gave Frydlender the opportunity to register the relentlessness of the downpour; in the street below a small wave threatens to soak the feet of the spirited teenagers who huddle on the narrow curb. Perched atop the building's vaguely prowlike corner are some pigeons that might be distant cousins of the dove that returned to Noah's Ark bearing an olive branch, signaling the ebbing of the terrible flood God had unleashed to punish sinful mankind and create a fresh beginning.

Flood at the same time is a reasonably straightforward record of the view from the artist's studio in a scruffy neighborhood of Tel Aviv. In Frydlender's pictures, the power of history and belief is registered in the patterns of everyday life. Many viewers (such as myself) need guidance to read the clues, and different viewers (no matter how well informed) will interpret the pictures differently. But the strength of the symbolic charge that each picture carries may be measured by the degree to which any one of them is inflected when considered in concert with one or more others: men of East Jerusalem playing cards in a café (plate 2); another exclusively male assembly of devout Haredi Jews on a ritual pilgrimage (plate 4); a mixed crowd of young hedonists strolling in Tel Aviv as Friday afternoon wanes toward sunset (plate 1).

Occasionally the symbolic tension is contained within a single frame: the swimming pool of an upscale condominium cheek by jowl with an old Jewish cemetery in a poor neighborhood whose minarets are visible in the distance (plate 5); the traditional seeds and nuts of the region offered in an overstuffed convenience store opposite refrigerated treats advertised in the Cyrillic alphabet familiar to immigrants from the former Soviet Union (plate 3).

Frydlender's Israeli panorama includes Arab and Jew, Ashkenazim and Sephardim, religious and secular, rich and poor, ancient and modern, young and old. The equanimity with which he takes it all in is the hallmark of his art. A good deal of the most ambitious art of the past few decades has drawn its themes and its creative energy from the polemics of group identity. Frydlender's recent work is all the more remarkable against that background, for its attentiveness to each individual group is rooted in its recognition of their multiplicity.

Opposite: Fig. 5. Detail of *Flood* (2003; plate 10)

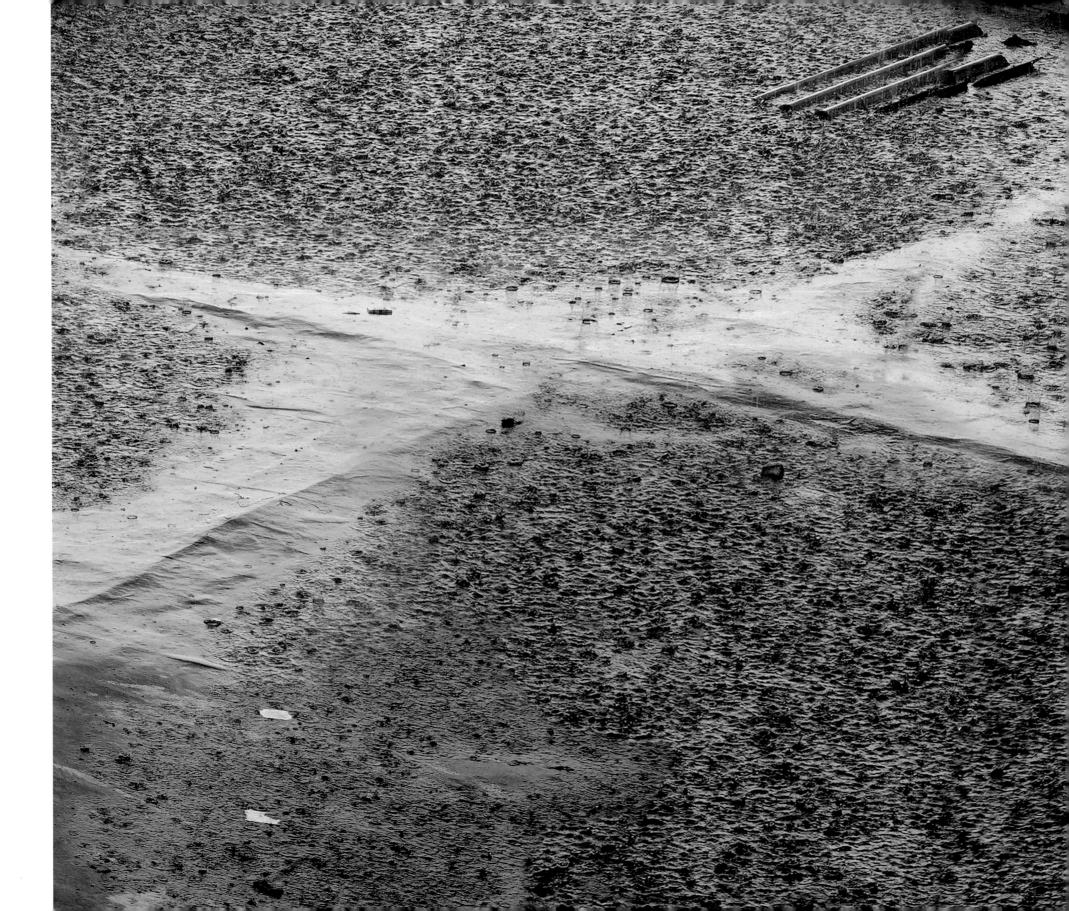

Acknowledgments

Bringing adventurous new art to a broad audience has always been one of the principal functions of The Museum of Modern Art, and we are delighted to add an exhibition of Barry Frydlender's recent photographs to that long tradition.

The exhibition was enthusiastically embraced by Jo Carole Lauder, who has been a leader of MoMA's Committee on Photography for many years and, with Ronald S. Lauder, has vigorously contributed to every dimension of the Museum's photography program. We thank them warmly for making the exhibition possible and for enabling the acquisition of the remarkable picture titled *Blessing* (2005). The exhibition and the acquisition form only the most recent chapter in an extraordinary record of generosity.

Harriette Levine is also a heroine of photography at MoMA, and we are grateful to her for enabling the acquisition of the first Frydlender photograph to enter the collection—*Flood* (2003). The first two of the Museum's photography collection galleries—The Noel and Harriette Levine Galleries 1 and 2—attest to the couple's exemplary generosity.

It would be a fool's errand to attempt to decide whether spirited dedication or professional competence is the more salient quality of the Museum's staff. Sarah Lewis, Curatorial Assistant in the Department of Photography, who has deftly coordinated the exhibition and this publication, joins us in thanking colleagues throughout the institution, notably in this instance Maria de Marco Beardsley, Jennifer Manno, and Jennifer Wolfe.

Under the leadership of Christopher Hudson, Kara Kirk, and David Frankel, the Department of Publications enthusiastically took on this project after the eleventh hour. Amanda Washburn, who designed the catalogue; Joanne Greenspun, who edited it; and Marc Sapir, who supervised production, deserve loud applause. All of us are indebted to Martin Senn in Washington, D.C., who made the excellent color separations.

We are pleased to thank Andrea Meislin and her staff at the Andrea Meislin Gallery in New York, who introduced Frydlender's work to the United States, and who have offered superb assistance at every turn.

Above all we are grateful to Barry Frydlender, who kindly gave his attention to this project in the midst of preparing a much larger, retrospective exhibition at the Tel Aviv Museum of Art. His thoughtfulness and grace, as well as his inventive, absorbing pictures, have made the experience of working with him rewarding indeed.

Glenn D. Lowry
Director

Peter Galassi
Chief Curator of Photography

Published in conjunction with the exhibition *Barry Frydlender: Place and Time* at The Museum of Modern Art, New York, May 17–September 3, 2007, organized by Peter Galassi, Chief Curator of Photography

The exhibition is made possible by Jo Carole and Ronald S. Lauder.

The accompanying publication is made possible by The John Szarkowski Publications Fund.

Produced by the Department of Publications
The Museum of Modern Art, New York
Edited by Joanne Greenspun
Designed by Amanda Washburn
Production by Marc Sapir
Color separations by Martin Senn
Printed and bound by Editoriale Bortolazzi-Stei s.r.l, Verona

The paper is 200 gsm Lumisilk.

Published by The Museum of Modern Art, 11 West 53 Street, New York, New York 10019-5497
© 2007 The Museum of Modern Art, New York
All works by Barry Frydlender © Barry Frydlender

fig. 2: © 2007 The Museum of Modern Art, New York
fig. 3: © 2007 David Hockney

Library of Congress Control Number: 2007923883
ISBN: 978-0-87070-718-6

Distributed in the United States and Canada by D.A.P./ Distributed Art Publishers, Inc., New York

Distributed outside the United States and Canada by Thames & Hudson Ltd., London

Front cover: Barry Frydlender. *Pitzutziya* (detail). 2002. Chromogenic color print, 31 1/8" x 9' 11/16" (79 x 276 cm). Collection of Suzanne and Jacob Doft, New York

Title page: Barry Frydlender. *Flood* (detail). 2003. Chromogenic color print, 49 3/16" x 7' 10" (124.9 x 238.8 cm). The Museum of Modern Art, New York. Acquired through the generosity of Harriette Levine

Printed in Italy